SEASIDE
PICKET FENCES

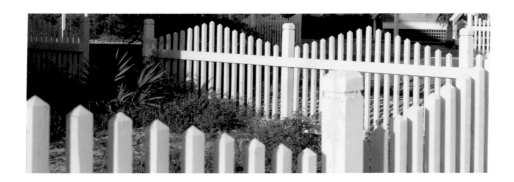

STEVEN BROOKE

PELICAN PUBLISHING COMPANY
Gretna 2003

Brief History of the Picket Fence

Human beings have an instinctual need to define the boundaries of their personal space. Whether it is a prehistoric cave, a medieval castle, or a two-bedroom house in the suburbs, the urge to announce our ownership and, if necessary, defend that property is real. These boundaries have included labor-intensive structures such as deep moats and stone walls. However, the most convenient and easily constructed form of territorial marking has been the fence.

Fences organize and shape physical space, provide security, establish entryways, and mediate between the public and private realms. Fences emphasize the dominance of the house within its enclosed garden. Within its borders the fence creates its own world. Apart from their utilitarian functions, fences also provide architectural ornament, echoing the design features of the house and contributing to the largesse of the neighborhood.

The wooden picket fence, the most common fence in the world, is relatively inexpensive and easy to construct. If maintained, it is surprisingly durable. In Serbia, one out of three wooden fences is older than the United States.

In the seventeenth century, the English and Spanish transported their fence-building traditions to the New World, primarily in the form of palisades used to create impenetrable fortifications. Pointed wooden stakes or logs, as much as twenty feet high, were placed vertically side by side, punctuated by openings for entries. Domestic fences were simply less forbidding interpretations of this style.

American colonists, eager to enclose their new settlements, built fences of tightly spaced, pointed split stakes called pales. These were driven into the ground and fastened to a horizontal beam at their top ends. The first colonial pale fence was recorded to have been built in 1633. This was the direct ancestor of the picket fence that ultimately became an icon of domestic American landscape.

The construction of fences was among the most essential activities of recently settled colonists. Wood was plentiful and woodworking was a common skill. Thus, picket fences of often-elaborate detail were built for the most practical of applications, such as separating livestock from crops. Fences also defined and protected all types of rural and urban spaces, such as graveyards, churchyards,

gardens, work yards, and even jails. Fences came to symbolize settlement and the possibility that ordinary people could be landowners in the New World.

By the mid- to late-eighteenth century, the growth of commercial urban centers brought new prosperity to larger numbers of citizens. This wealth was readily expressed in domestic architecture. Throughout the country, the front yard fence became a badge of individual achievement.

European and later American architectural pattern books of this era illustrated historic styles of picket fences and suggested ways to incorporate them as boundaries for both domestic and public architecture. Inspired by these pattern books, the grand houses of the most prominent citizens were set off from the street by elaborate fences, no longer just an agricultural necessity. For the modest homes of the growing urban and suburban middle classes, the picket fence was an emblem of dignity and good taste. In the still-lawless settlements of the Western wilderness, the humble picket fence served as a proud declaration of stability and civilization.

Mass-produced wood picket fences became commercially available in the 1850s. Contemporary architectural critics predicted that the mass production of picket fences would lead to a landscape marked by a numbing stylistic sameness. However, the remarkable variety of available patterns were imaginatively combined and altered in ways as individually expressive as local accents.

From the second half of the nineteenth century until World War II, the front porch was the bridge between family life and community life. The automobile was

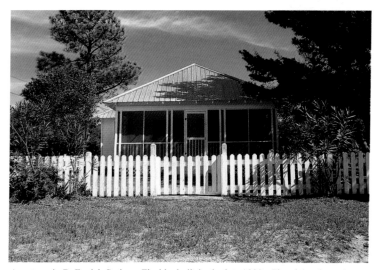

A cottage in DeFuniak Springs, Florida, built in the late 1890s. The picket fence is a copy of the original and is typical of the fences in this area.

not the dominant force in residential planning that it unfortunately is today. Consequently, pedestrian traffic on urban and suburban sidewalks was the rule.

and residential fences in order to share spaces and views and emulate "natural" settings. The picket fence all but disappeared.

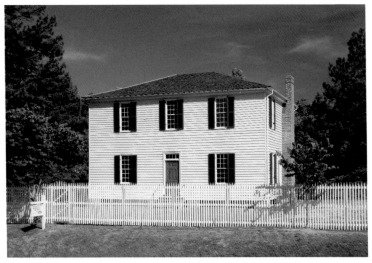

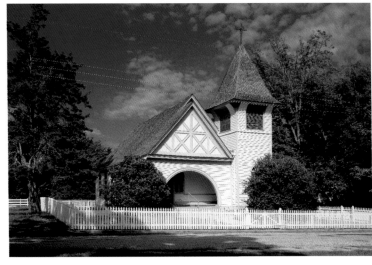

The human scale of the picket fence contributed to the conviviality of street life.

However, by the mid-twentieth century, except for a brief revival of picket fences accompanying Colonial Revival houses, modernist landscape theory encouraged minimizing or eliminating boundaries

Developments were built without sidewalks. Front yards opened up completely. The focus of family life was no longer toward the street, which was perceived as too threatening. Roads were widened to accommodate the increasing number of cars. Unfortunately, there was no automotive equivalent to engaging in

conversation with the casual passerby. Movies such as Tim Burton's satirical *Edward Sissorhands* admittedly exaggerate the resulting impersonal emptiness of much mid-twentieth-century American suburban design, but the sterility of such developments is regrettably real.

In the late 1970s, architects and planners, frustrated by the prospect of ceaseless suburban sprawl, proposed alternative models for residential development. Concerned with preserving our architectural heritage, they drew heavily upon town designs of earlier eras, especially those of the Southern United States. Their designs included sidewalks, back alleys, detached garages, front porches . . . and white picket fences. Their efforts achieved international notoriety when they were employed in the design of a new town in the Florida Panhandle.

Historic Washington, Arkansas, is a mid-nineteenth century town on the Southwest Trail. Many of its structures have picket fences reconstructed to match the originals. Photos from *Historic Washington, Arkansas,* by Steven Brooke (Pelican, 2000). OPPOSITE LEFT: The 1836 Courthouse. OPPOSITE RIGHT: The Presbyterian Church. RIGHT: Picket fence-lined walkway leading to Pilkington Hall, the newly reconstructed Town Hall modeled after the building which stood on that spot in 1907.

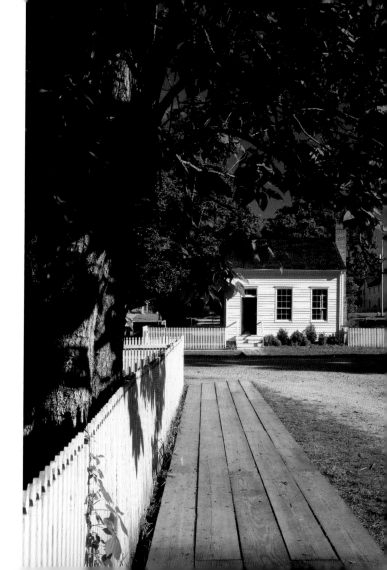

Picket Fences in Seaside

Seaside, the Florida Panhandle beach town on the Gulf of Mexico envisioned by and built under the guidance of Robert Davis, is a benchmark accomplishment in American design. Widely celebrated in books and magazines, Seaside and the architects and planners with whom Davis worked received numerous prestigious national and international awards and accolades including *Time* magazine's Design of the Decade award, several National American Institute of Architects Design awards, and a citation by His Royal Highness the Prince of Wales.

The success of Seaside, whose planning was based on nineteenth-century traditional neighborhood development principles, spawned an international movement called the New Urbanism. This rapidly growing force in architecture and planning promotes modestly scaled, pedestrian-oriented development as an antidote to the urban sprawl that continues to plague our cities.

The fundamental principle around which Seaside was developed is that people would walk if walking were convenient and pleasant, and if the range of life's daily requirements were close at hand. To that end, Seaside's planners developed a Master Plan and Urban Code that reads like an outline for a nineteenth-century town. The Code was based on a compilation of the fundamental architectural qualities and features of Southern United States vernacular architecture and communities.

Ultimately, the Seaside Code was a synthesis of

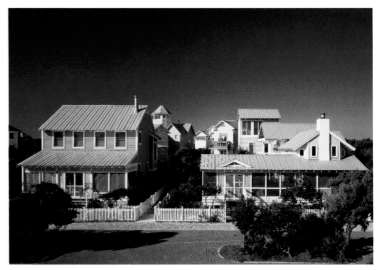

A Seaside streetscape illustrating aspects of the Seaside Code: porches, towers, pitched roofs, and picket fences defining the steet and footpath edges.

many vernacular traditions ranging from Carpenter Gothic to those of Charleston and the antebellum South. These traditions are expressed in elements such as front porches, towers, pitched roofs with deep overhangs, segmented windows, generous boulevards, comfortably scaled buildings, indigenous landscape, public structures such as gazebos and beach pavilions, and town centers. These elements combine to create a general atmosphere of neighborliness and informality.

Picket fences are perhaps the most recognizable elements of the Seaside Code. The Code required white painted-wood picket fences at the street-front property lines. They were required not only for their aesthetic appeal but also for their ability to define the edge and maintain the scale of the street. Their presence throughout the town significantly encourages pedestrian traffic.

With only a few houses and their accompanying picket fences, a gazebo, and a beach pavilion, Seaside's first street, Tupelo Street (center), defined

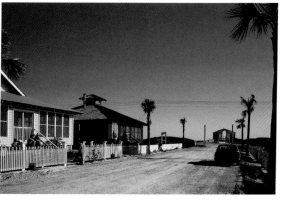

the town's character. As Seaside developed, picket fences were used to mark the edges of pathways and streets only partially built. The fences themselves were sufficient to provide potential homeowners with a sense of the scale of the street.

Dirt footpaths throughout Seaside provide additional networks for pedestrian traffic, especially for children. These, too, were required by the Seaside Code to have picket fences.

Because individual fence patterns were not to be replicated on the same street, the fences at Seaside are as individual as their homeowners. *Webster's Dictionary* defines "picket" as a pointed fence. However, the Code allowed for more varied styles. They include classic designs with protruding pickets (pp. 12-17); classic designs with flat tops (pp. 18-23); decorative pickets (pp. 24-25); varieties of picket ends (pp. 26-31); pickets with multiple heights (pp. 32-35); elaborate picket patterns (pp. 36-38); multiple widths (p. 39);

double horizontal layers (pp. 40-43); and undulating picket patterns (pp. 44-48).

With most of Seaside's residential construction completed and the landscape maturing, the picket fences contribute to the sense of procession as one walks through the town. They define corners, lead the eye around bends, and frame groups of houses both large and small.

As they have done for centuries in towns throughout the world, Seaside's picket fences invite meandering, encourage neighborliness and conversation, and gracefully announce the presence of genuine civic life.

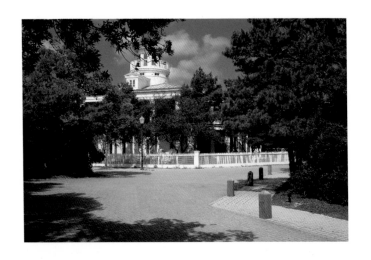

Picket fences define the street edges, lead the eye, and provide comfortable places to stop and chat with neighbors.

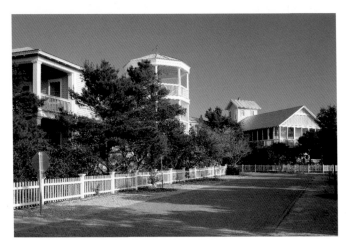

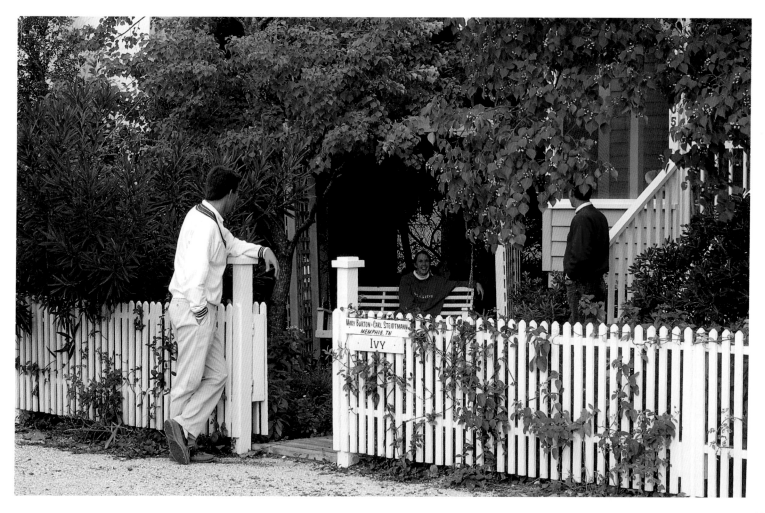

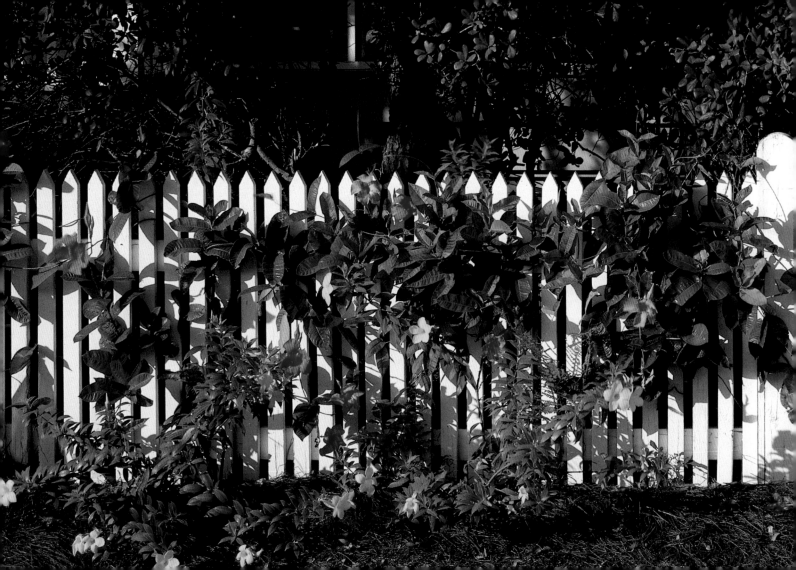

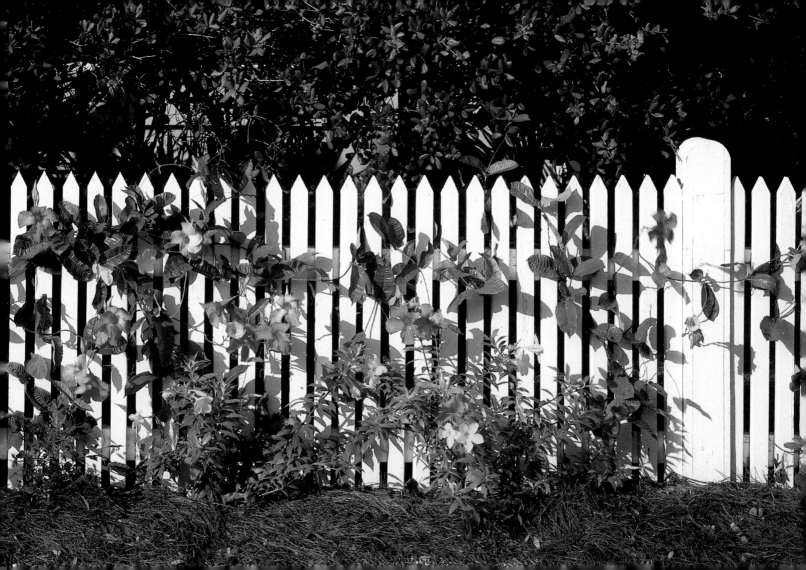

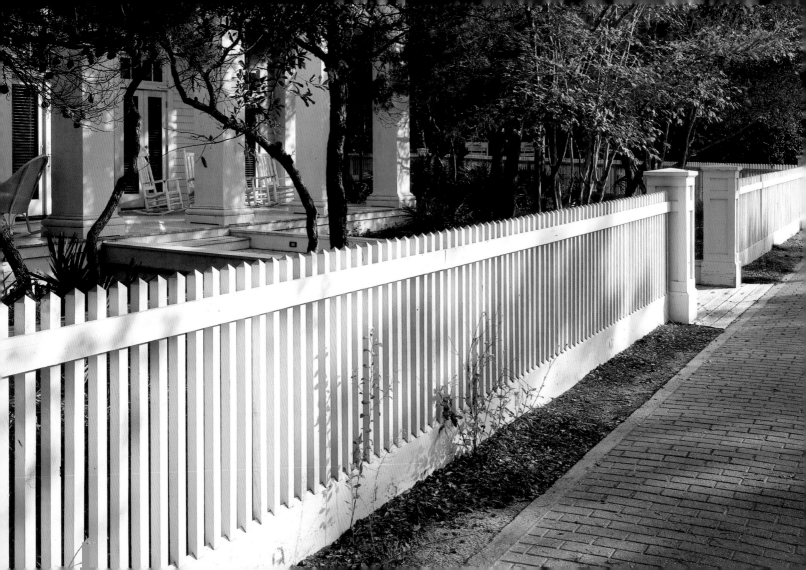

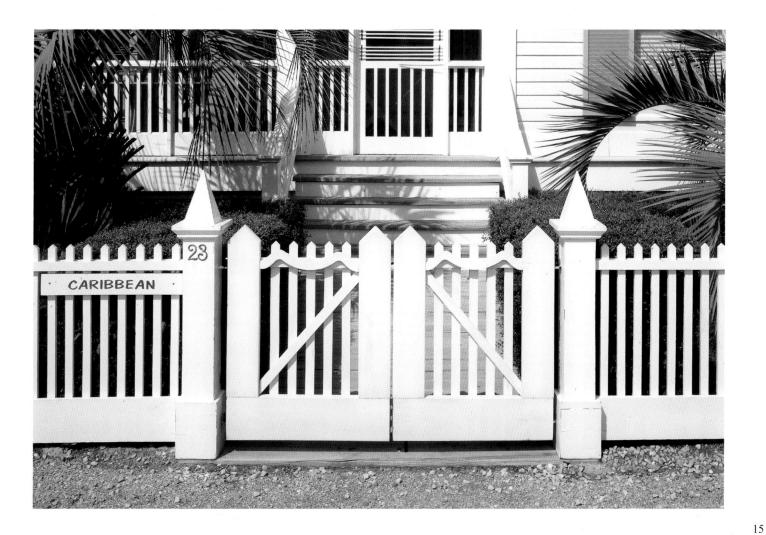

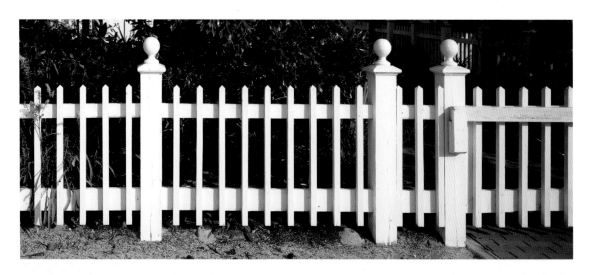

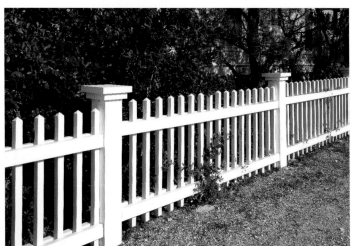

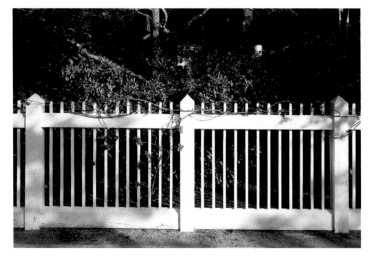

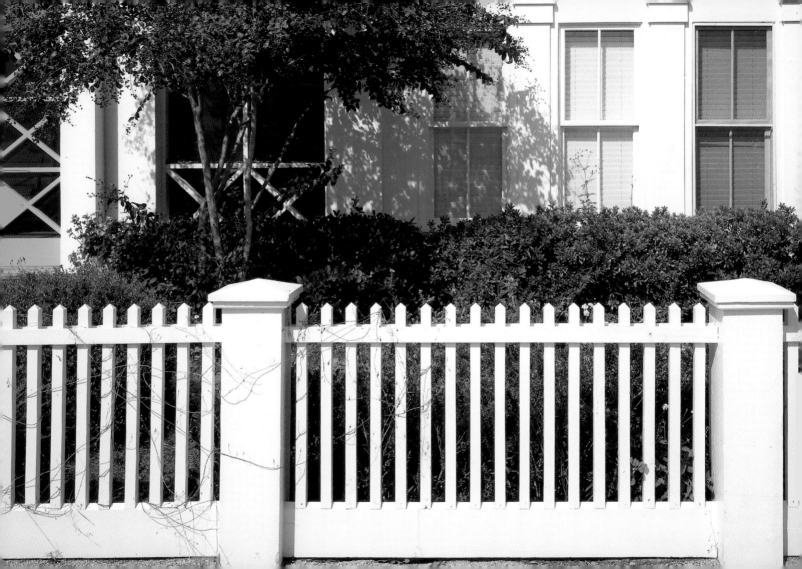

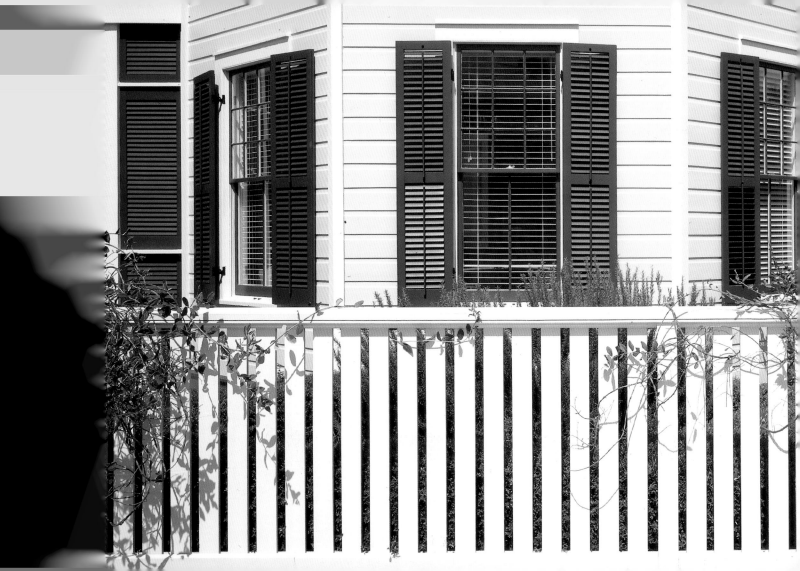

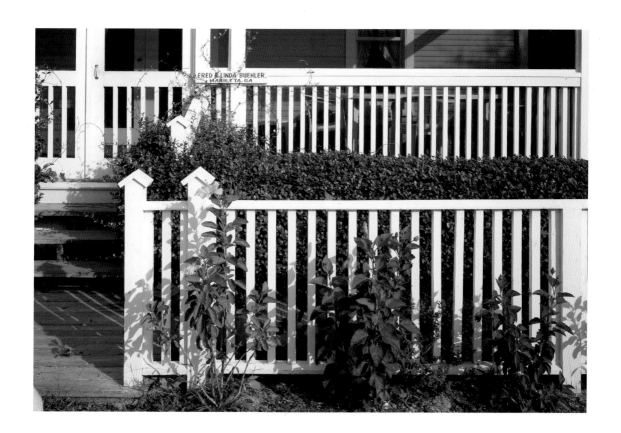

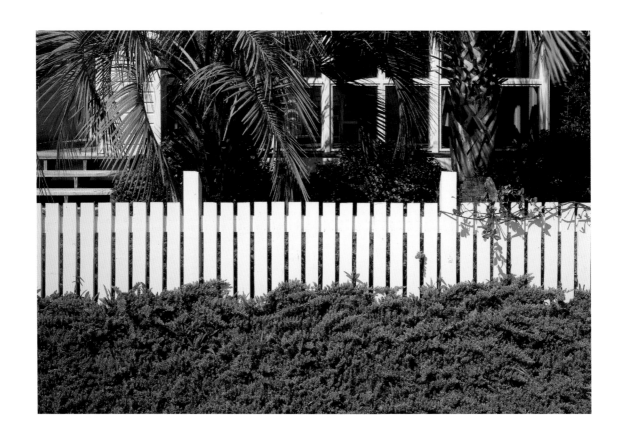

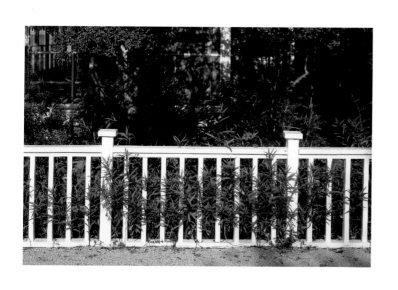

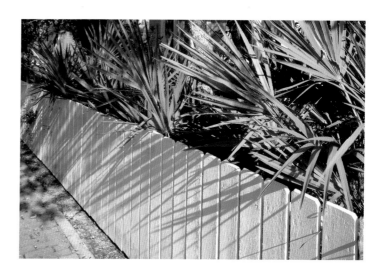

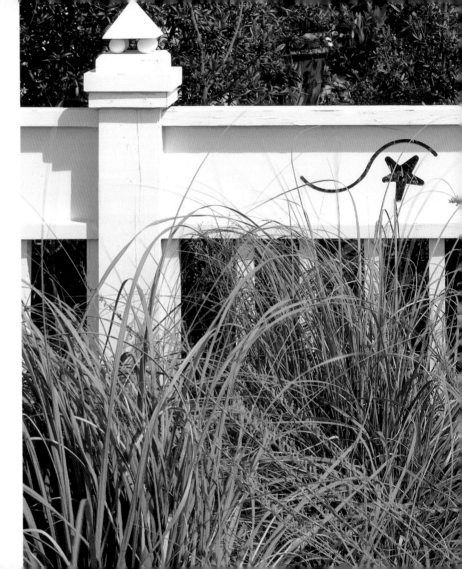

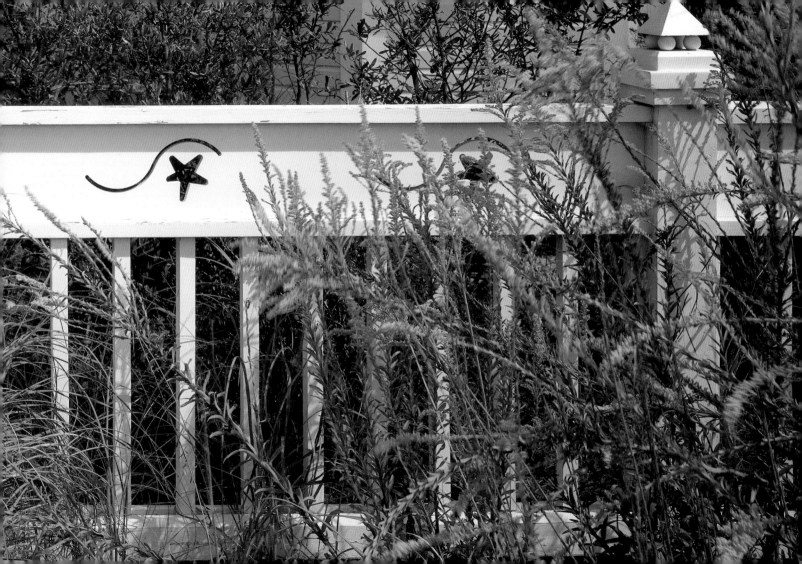

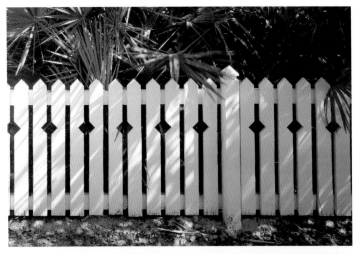
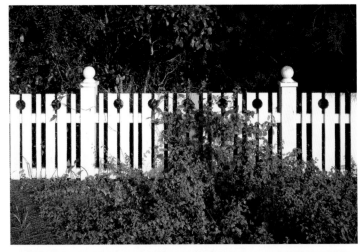
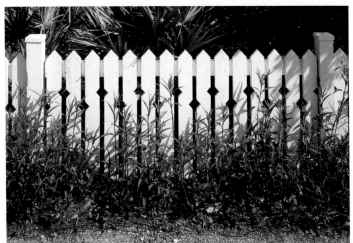

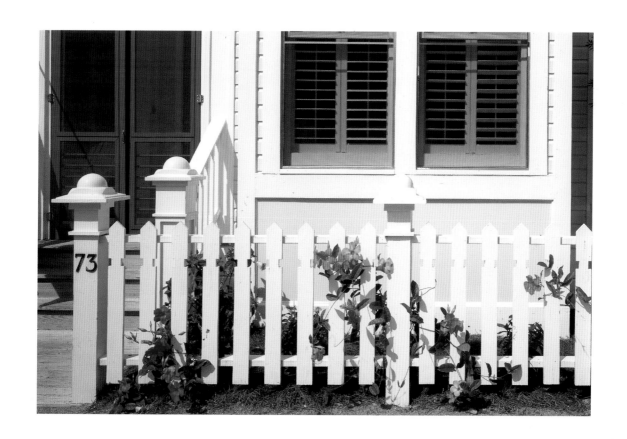

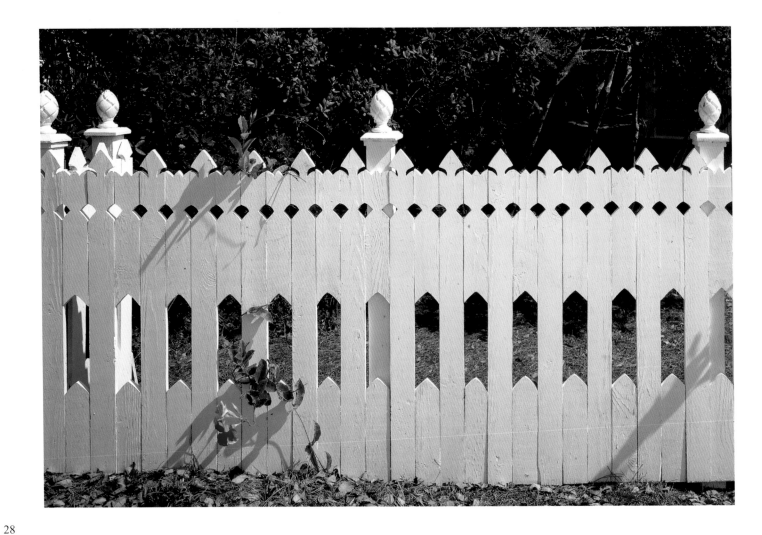

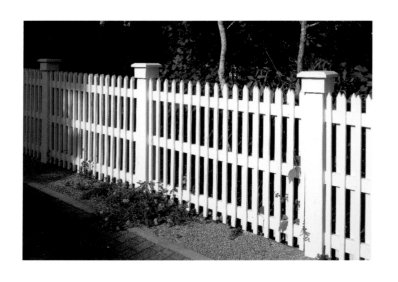

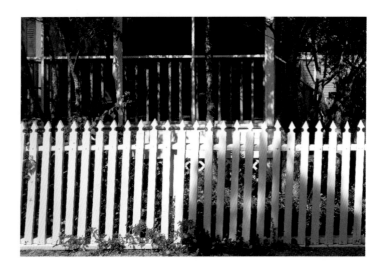

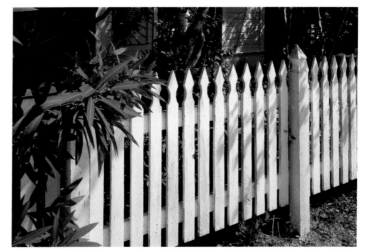

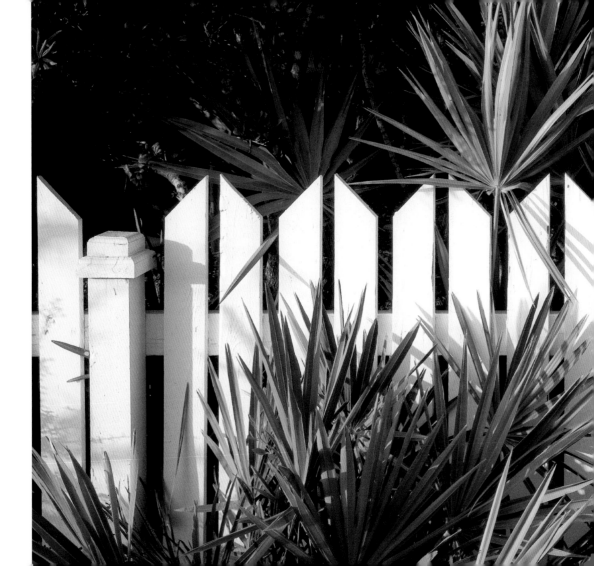

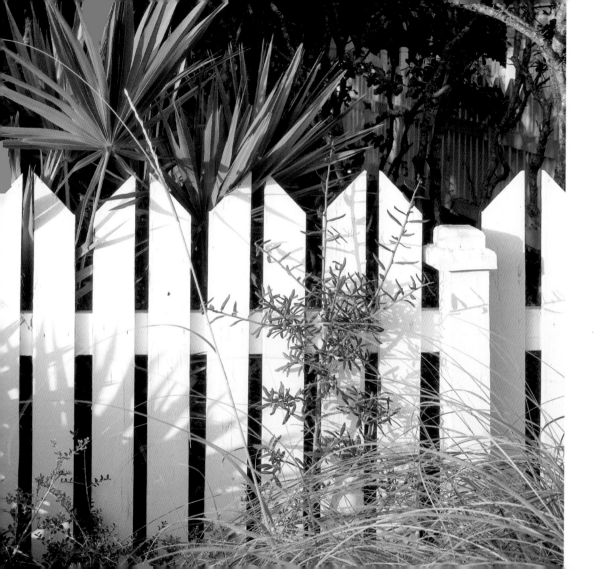

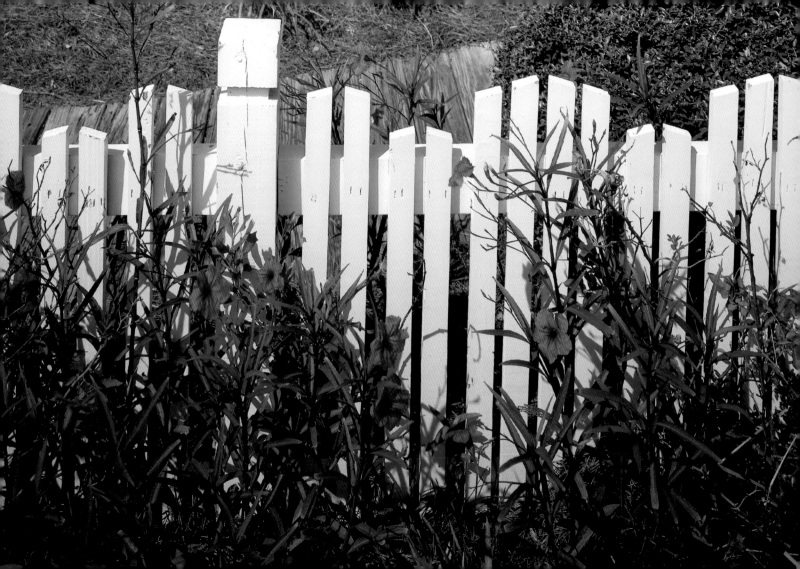

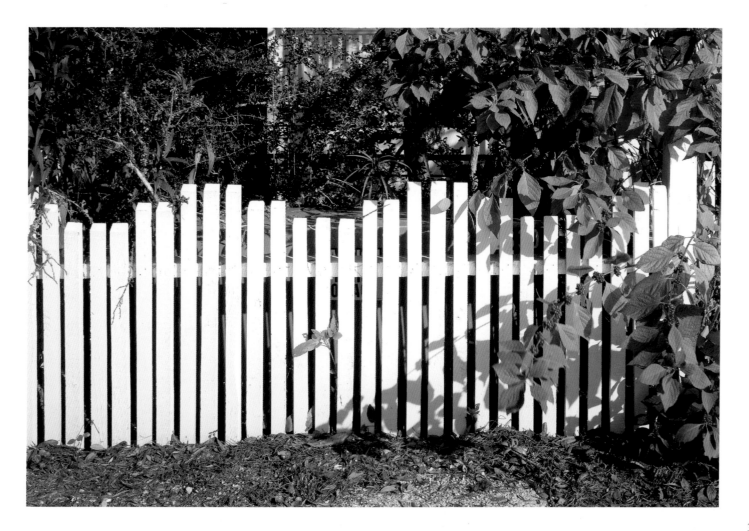

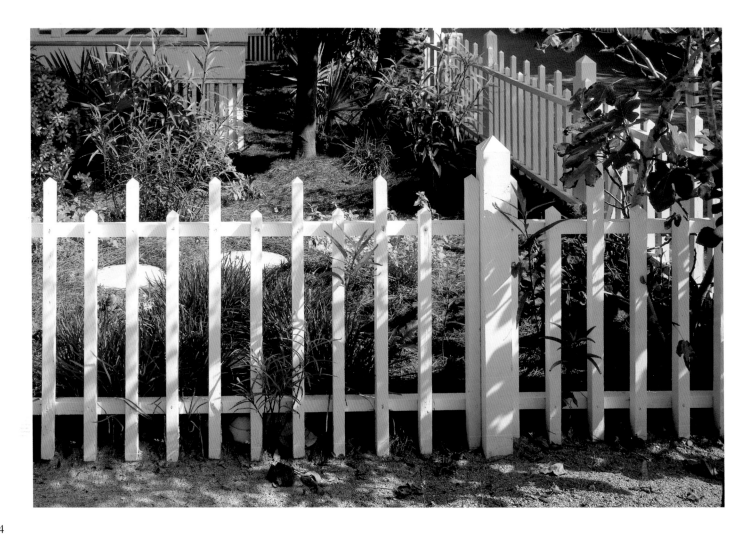

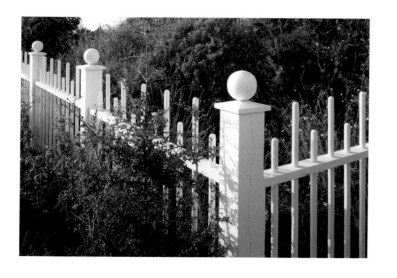

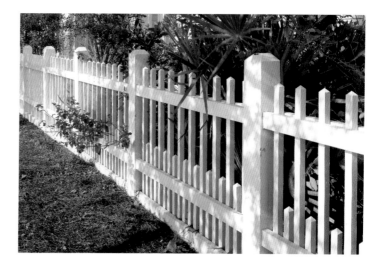

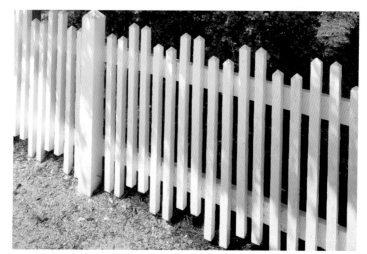

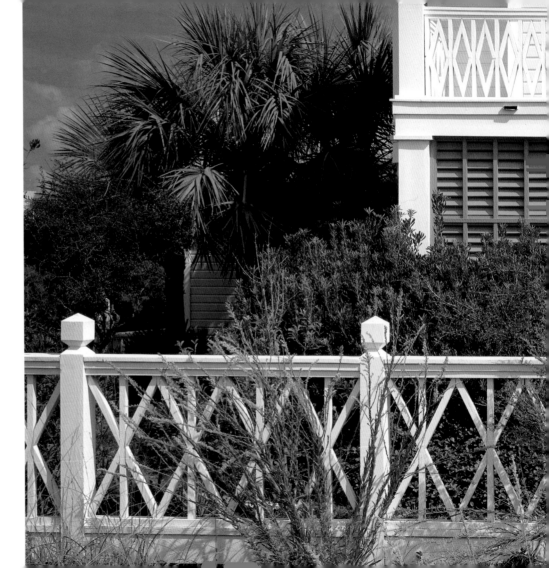

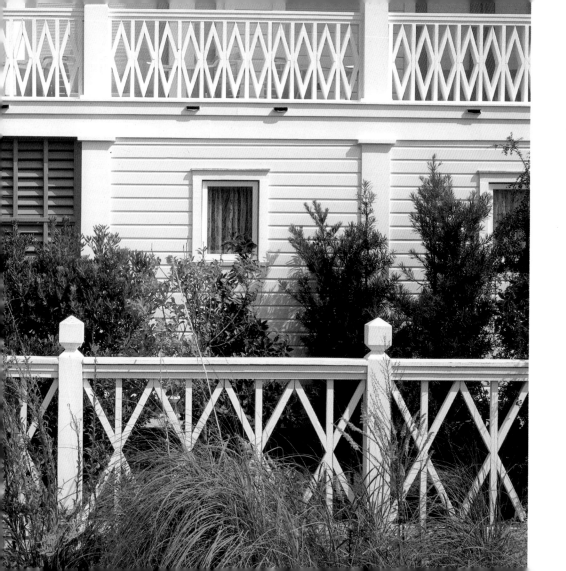

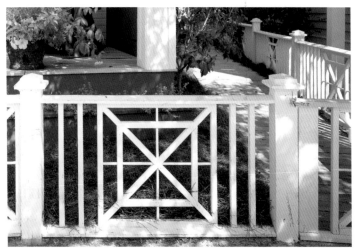

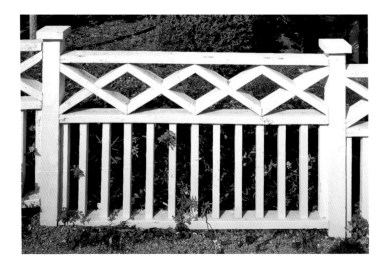

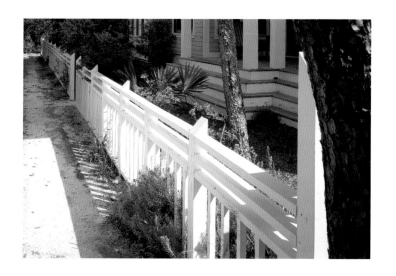

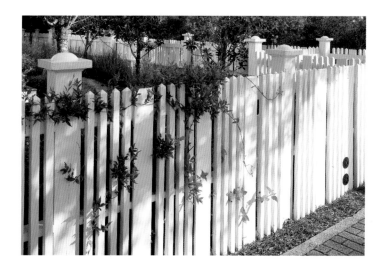

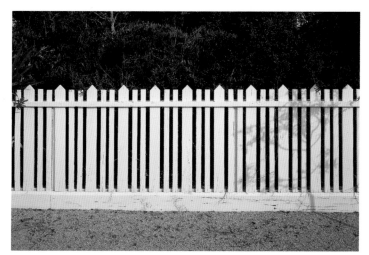

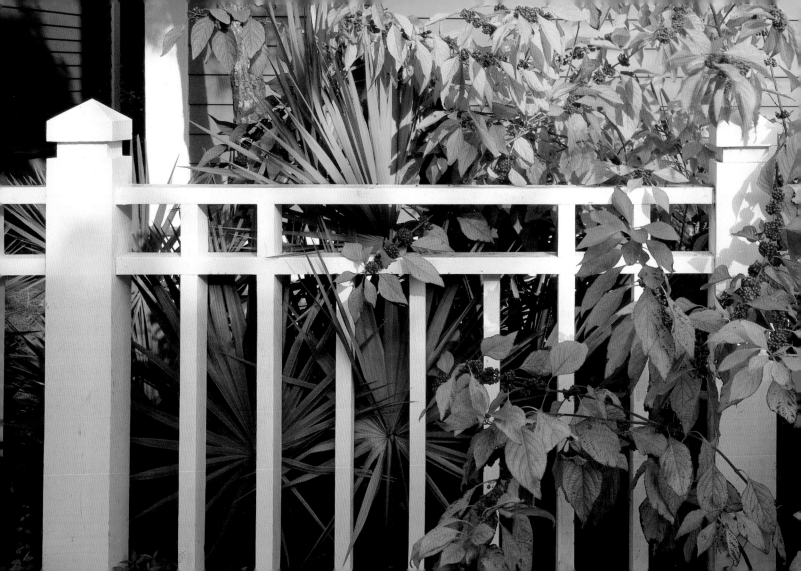

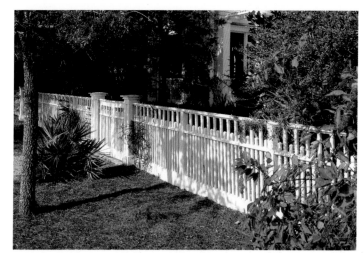

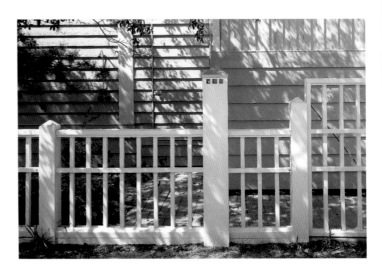

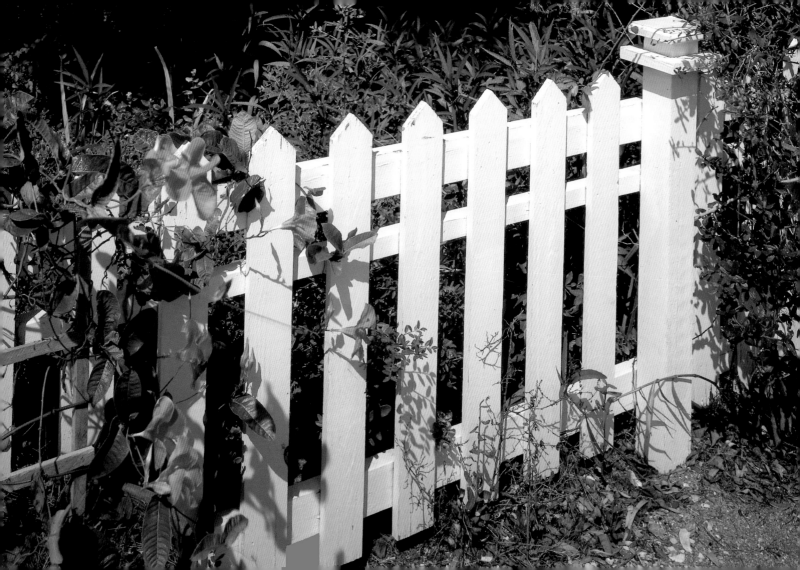

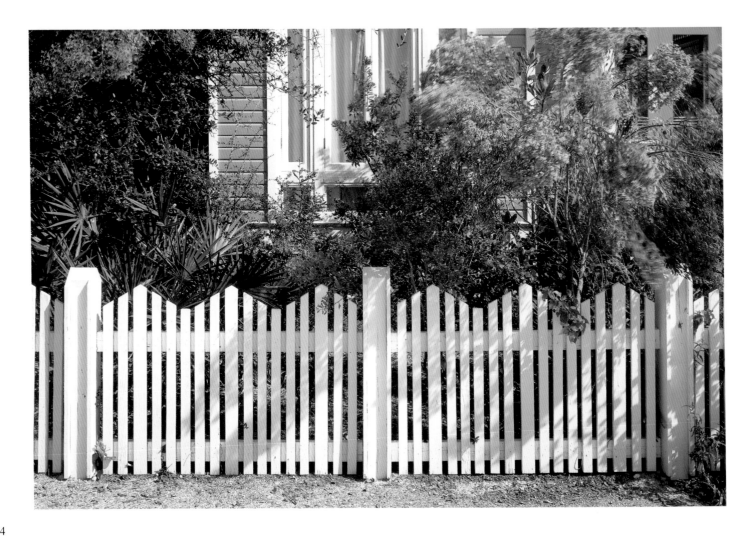

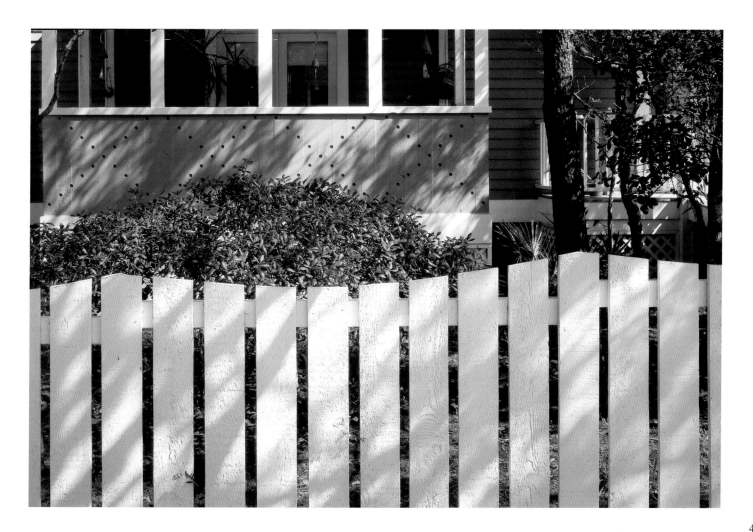

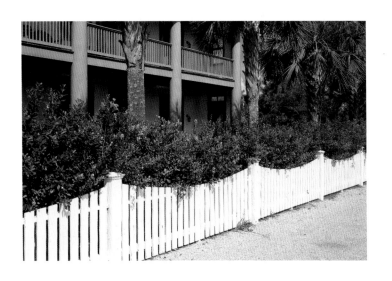
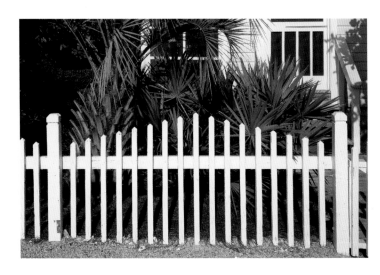

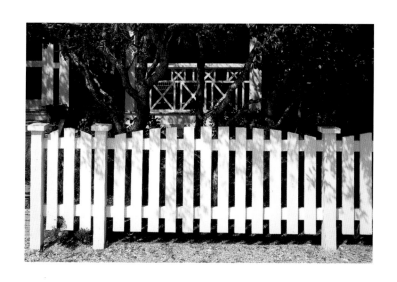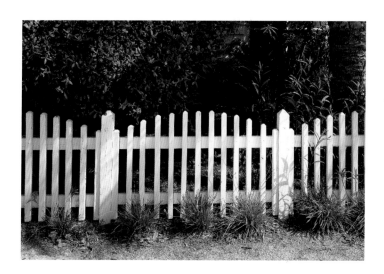

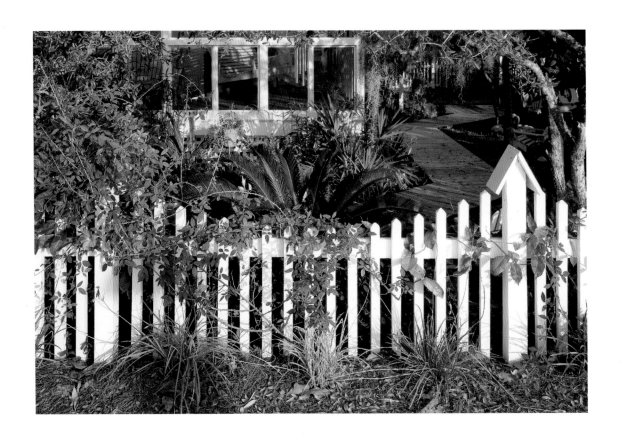